T0061826

Warhol-isms

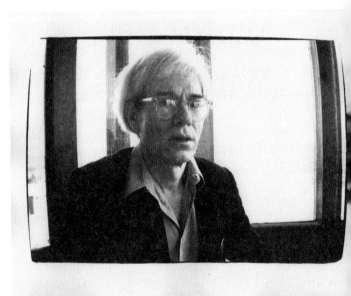

Warhol-isms

Andy Warhol

Edited by Larry Warsh

PRINCETON UNIVERSITY PRESS
Princeton and Oxford

in association with
No More Rulers

Requests for permission to reproduce material from this work
should be sent to permissions@press.princeton.edu
Published by Princeton University Press,
41 William Street, Princeton, New Jersey 08540
In the United Kingdom: Princeton University Press,
99 Banbury Road, Oxford OX2 6JX
press.princeton.edu
in association with
No More Rulers
nomorerulers.com
ISMs is a trademark of No More Rulers, Inc.

P PRINCETON ~~NO MORE RULERS~~

Library of Congress Cataloging-in-Publication Data
Names: Warhol, Andy, 1928–1987 author. | Warsh, Larry, editor.
Title: Warhol-isms / Andy Warhol ; edited by Larry Warsh.
Description: Princeton : Princeton University Press in association with No
More Rulers, [2022] | Series: Isms | Includes bibliographical references.
Identifiers: LCCN 2021049276 | ISBN 9780691235035 (hardcover)
Subjects: LCSH: Warhol, Andy, 1928–1987—Quotations.
Classification: LCC N6537.W28 A35 2022 | DDC 700.92—dc23/eng/20211026
LC record available at https://lccn.loc.gov/2021049276
British Library Cataloging-in-Publication Data is available

This book has been composed in Joanna MT
Printed on acid-free paper. ∞
Printed in the United States of America
1 3 5 7 9 10 8 6 4 2

CONTENTS

INTRODUCTION

Andy Warhol's contemporary historical influence is outstanding—from fine art, film, fashion, and music to the very fabric of American pop culture and our relationship to consumerism and commercialism. He was—and remains—the original King of Pop.

I was in my early twenties and living in New York when I was introduced to Andy Warhol and his art. A close friend of mine who used to trade watches, jewelry, and other objects with him was the first to show me Warhol's legendary *Coca-Cola*, *Elvis*, and *Marilyn* paintings—that was my firsthand glimpse of Warhol's canvases (as hand-rolled or rolled in tubes). Those iconic images formed the backdrop of an outrageous era. Andy was someone I would never forget.

Can you imagine if I had started my compulsive collecting episode of life at that time? I was too young then.

Those were wild times, full of creative crossover, and in the years that followed, Andy's sheer cultural weight and singular persona had a profound impact on me. I was lucky to understand firsthand the fine-tuned machine that was Andy's artistic practice and his studio, known as "the Factory," as named by Andy himself.

Andy's creativity was boundless. Not only a fierce artist, as a writer he penned more than eight hundred diary pages, including more traditional essays and magazine publishing pieces. Regardless of his brilliance, love of reading, and unrivaled artistic output, he seemed to enjoy cultivating the celebrity of someone slightly detached and somewhat disinterested. This from a man who once stated: "I like boring things."

Warhol was a master at transforming the format of the artist's interview into a work of art itself, giving just enough of himself to leave everyone wanting more.

Nevertheless, Andy's work continued on the path that was already well established by many significant art figures by way of his command of patronage and portraiture. He knew exactly how to tap into cultural trends to parlay his notoriety. And he knew how to make the move when it served his vision. The timeless, glittering, Warholesque visions of Elizabeth Taylor, Marilyn Monroe, Jackie Kennedy Onassis, Debbie Harry, and other goddesses of the day are among the most celebrated images in all of global contemporary art.

Indeed, Andy was an extremely sought-after subject and probably one of the most frequently interviewed cultural figures of the late twentieth

century. He is revered among his fandom for his artwork and equally for his public eccentricity, his intellectual quips, and his unforgettable aphorisms.

As an orchestrator of the cultural milieu, Warhol brought together the talented and the famous to bolster their celebrity and his own—from Lou Reed and the Velvet Underground to the 1985 collaborative paintings that he did with Jean-Michel Basquiat. For that he is an influencer for all time, and his body of work captures the moment like a visually mesmerizing encyclopedia.

The purpose of this book is to present the words of Andy Warhol in a format that is accessible and engaging, thoughtful, and absolutely entertaining. My hope is that *Warhol-isms* provides readers with a deeper insight into Andy's

literal words, singular essence, and mind as an artist and individual, preserving his distinct voice for generations to come.

LARRY WARSH
NEW YORK CITY
NOVEMBER 2021

Warhol-isms

Life

My name is Andy Warhol. I live on Lexington Avenue in New York. Actually, I spend most of my time at the factory on East 47th Street. (12)

———

I went to [a psychiatrist] once, and he never called me back. (1)

———

Am I really doing anything new? (9)

———

They always say that time changes things, but you actually have to change them yourself. (7)

———

I don't really believe in love. I sort of believe in liking. (22)

———

You can't really prepare for anything. (17)

———

I don't want to talk about negative things. (3)

———

I'm so confused about everything. There are
so many problems. (35)

———

I really like to work a lot. It makes time
go by fast. (1)

———

When I was young I always wanted to
look older, and now that I'm older I want
to look younger. (16)

———

I wear Stephen Sprouse black pants, black
T-shirt, black turtleneck, black shirt, black
leather jacket and Adidas shoes. (6)

———

I'm so scarred I look like a Dior dress. (31)

———

I sleep with my underwear. And my corset. (1)

———

Everything is more glamorous when you do it
in bed, anyway. Even peeling potatoes. (7)

———

I don't believe in credit cards. (26)

———

I really hate heights. I always like to live
on the first floor. (1)

———

Did you learn a new word today? (30)

———

My new art form is vacuum cleaning.
Or washing dishes. (21)

———

Anybody can do what I do. (13)

———

I think I was twenty-five when I first had
sex ... I stopped at twenty-six. (25)

———

I face everything straight on. (2)

———

I don't want to live forever, do you? (35)

———

I was always sick [in high school] so I was always going to summer school and trying to catch up. (1)

———

The part about the parties I attend is probably overplayed. Most of them are well covered by the press. That accounts for my name appearing so often. (2)

———

I don't know how to smoke.
I never sleep either. (16)

———

I've always wondered how people could drive
cars. I can never remember what to do. (16)

———

Edie [Sedgwick]'s hair was dyed silver,
and therefore I copied [her] hair because I
wanted to look like Edie because I always
wanted to look like a girl. (16)

———

Everyone and everything is interesting. (19)

———

Do you think living is worth living? (35)

———

Some of my marbles are missing. That's my philosophy. (21)

I had Campbell's Soup every day for lunch for about twenty years. And a sandwich. (1)

I had just ridden up in the elevator with [Valerie Solanas] and I turned around to make a telephone call and just heard a noise, that's all. ... [M]y life didn't flash in front of me or anything. It was too painful. I put it together after a couple of weeks ... what happened. (1)

Life hurts so much. (19)

Do you think if the whole world becomes communist they'll just write about love? (35)

———

What's your natural color? Pink. (1)

———

I have paint clothes. They're the same kind of clothes I wear every day, with paint on them. (1)

———

What's your style? Anti-fashion. (6)

———

I like work and work is what I do—a lot. (22)

———

Why do people think artists are special?
It's just another job. (7)

———

I'm not sure of anything. ... I'm not certain of
anything. ... It's not what I'm not certain
of, it's what I can do that counts. (12)

———

I don't think that getting your name around
means that you make a lot of money. (1)

———

I like to work when I'm not working—do
something that may not be considered work,
but to me it's work. Getting exercise by going
to the grocery store. (1)

———

I think that once you see emotions from
a certain angle you can never think of them
as real again. That's what more or less
has happened to me. (7)

———

I read a wonderful article in *Christopher Street*.
It was about two boys that met and had an
affair. Then they broke up. They had a few
pictures they took of each other. Then from
the pictures they recollected how their affair
went. It was fascinating. It could have been a
boy and a girl. It just happened to be two
boys. Each boy had a different fantasy. It was
fascinating how two people do things for
different reasons. You can be really close and
you're still not really close at all. (35)

———

The most exciting thing is not-doing-it. If you
fall in love with someone and never do it,
it's much more exciting. (7)

———

Sex is nostalgia for sex. (7)

———

Some [people] would be lucky if they could
get a boy and a girl at the same time. I mean,
that's what they should marry because
they could have both. (24)

———

Beauty doesn't have anything to do with sex.
Beauty has to do with beauty and sex has
to do with sex. (7)

———

I don't have any sex dreams. (25)

Sex is more exciting on the screen
and between the pages than between
the sheets anyway. (7)

You do think positively then.
Not consciously but I try to. (6)

It's too hard to look in the mirror. There's
nothing there. (6)

If you were given three wishes, what would you wish for? The first wish would be to be able to wish. (6)

———

What is your day like? I sleep with the television on. I wake up two or three times to go to the bathroom. I watch TV and get up at 7:30. I watch more television. MTV. I walk to work. I work until 9:00 and then try to go to a movie. (6)

———

If you had a car, what kind would you have? One with good brakes. (6)

———

What's your favorite number? Zero. (6)

———

Do you believe in feelings and emotions?
No I don't, but I have them. I wish I didn't.
(30)

———

Romance is finding your fantasy in people
who don't have it. (7)

———

I'm quasi-romantic, at least. (11)

———

Why can't it just be magic all the time? (37)

———

Sometimes people let the same problem make them miserable for years when they could just say: "So what." That's one of my favorite things to say. "So what." (7)

———

Is my hair too flat? (6)

———

I have a really loose interpretation of *work*, because I think that just being alive is so much work at something you don't always want to do. (7)

———

Being born is like being kidnapped. And then sold into slavery. People are working every minute. The machinery is always going. Even when you sleep. (7)

———

The biggest price you pay for love is that you have to have somebody around, you can't be on your own, which is always so much better.

(7)

———

Life hurts so much. If we could become more mechanical, we would be hurt less—if we could be programmed to do our jobs happily and efficiently. (19)

———

Since I was shot, everything is such a dream
to me. I don't know what anything is about.
Like I don't even know whether or not I'm
really alive or—whether I died. It's sad. Like
I can't say hello or goodbye to people.
Life is like a dream. (31)

———

Soups are like paintings, don't you think?
Imagine some smart collector buying up
Mock Turtle [soup] when it was available and
cheap and now selling it for hundreds
of dollars a can! (9)

———

Are you satirical, Andy? No, I'm simple. (11)

———

I was given the same food for twenty years: soup and sandwiches. And I can tell you, my favorite is Campbell's Tomato Soup. (32)

———

I liked what I was doing before and I like what I'm doing now. (11)

———

Do you have any secrets you'll tell after everyone's dead? If I die, I'm not letting on. (1)

———

I eat food fast … I eat health foods fast. (6)

———

I have these time capsules. All the mail I get
and things I mark the date on and store down
in the basement. I do twenty of them a year.

(6)

———

Do you know the Campbell Soup Co. has not
sent me a *single* can of soup? And I've
bought every flavor. (9)

———

Culture

We're sponsoring a new band, it's called the Velvet Underground. ... Since I don't really believe in painting anymore I thought it would be a nice way of combining ... music and art and films all together. (14)

———

I believe media is art. (20)

———

In the '60s everybody got interested in everybody.

In the '70s everybody started dropping everybody.

The '60s were clutter.

The '70s are very empty. (7)

———

[The first artist to influence me] must have been Walt Disney. I cut out Walt Disney dolls. It was actually Snow White that influenced me. (1)

I still think Walt Disney is
[the world's greatest living artist].
He's dead. I know, but they still have him in plastic, don't they? (1)

I always say [I admire] Walt Disney.
That gets me off the hook. (25)

It was so funny to hear Hugh Downs say: "As Andy Warhol once said, in fifteen minutes everybody will be famous." People on TV always get some part wrong, like—"In the future fifteen people will be famous." (4)

———

I don't change the media, nor do I distinguish between my art and the media. I just repeat the media by utilizing the media for my work. (20)

———

What's your favorite vice? *Miami Vice.* (6)

———

I like boring things. (31)

———

New things are always better than old things.
(1)

I think people should like all the things that aren't really that good. (5)

I've been referred to as a Platonist. (12)

Sociological critics are waste makers. (9)

You have to do stuff that average people don't understand, because those are the only good things. (4)

I believe in all religions. That's the kind I am.
(18)

———

I always liked opera; I used to go when I was
very young. (30)

———

I went to vote once, but I got too scared.
I couldn't decide whom to vote for. (1)

———

It'd be so nice if you just told me the sentence
and then I could repeat it. (38)

———

The only Marx I knew was the toy company.
(1)

———

I think you should go to F.A.O. Schwarz and buy a new toy every day and just put it away.

(1)

A Coca-Cola bottle—when you buy it, you always think that it's yours and you can do whatever you like with it. Now it's sort of different because you pay a deposit on the bottle. We're having the same problem now with the John Wayne pictures. I don't want to get involved, it's too much trouble. I think that you buy a magazine, you pay for it, it's yours. I don't get mad when people take my things. (3)

The food was good, but the caviar only came around once. (4)

During the '60s, I think, people forgot what emotions were supposed to be. And I don't think they've ever remembered. (7)

Some people think violence is sexy, but I could never see that. (7)

Do you believe in the end of the world?
No. I believe in *As the World Turns*. (1)

I go to a party and these little kids have become drag queens. They think they are the only people who ever thought of being a drag queen, which is sort of weird. It's like they invented it, and it's all new again, so it makes it really interesting. (23)

———

I don't want to talk long this morning. I want to get over to Bloomingdale's before it's too crowded. (4)

———

They should have all TV commercials with just soap operas in between. ... But make them more entertaining, [so] that you'd have people watching the commercials like you'd watch soap operas. (8)

———

Today on the *Phil Donahue Show* they had maids on. They now call themselves household technicians. They're trying to start a union of household technicians. It was really weird. They were all Blacks. They didn't have any white household technicians. (35)

———

We have a newspaper and I have to do a lot of
interviews, and I never know what to ask so
that's hard work for me. (28)

I don't think there was an underground. …
It's a silly word. (1)

Buying is much more American than thinking
and I'm as American as they come. (7)

No one escapes the media. Media influences
everyone. It's a very powerful weapon. (20)

Every time I go to the airline [news]stands
they never have anything I want. (34)

———

I believe in television. It's going to take
over from movies. (13)

Art

I had one art class. (1)

In the sixties everything changed so fast. First it was pop, and then they gave it different names, like conceptual art. They made it sound like it was modern art or something because it changed so fast, so I don't know whether pop art was part of that, or whether it was something else, because it happened so fast. (23)

It doesn't matter what you do. You can change it, become an abstract expressionist, the next week you can turn into a pop artist or something else. Without feeling that you've given up something. (5)

I never thought Dada had something to do
with pop, it's sorta funny, the name is so
similar. They're really the same name. (5)

———

I think that's the best artist, a wall painter. My
favorite painting is when they spackle. That's
the look I like. And the next year paint over
that. That's the look. (6)

———

I think [art is] going to become fashion art.
That's the direction it's going. (24)

———

I hate to go to museums and see pictures of
the world because they look so important, but
they don't really mean anything. (38)

———

I think graffiti is really terrific. (15)

I want somebody to do all my
paintings for me. (5)

I feel an artist's signature is part of style,
and I don't believe in style. I don't want my
art to have a style. (20)

I'm anti-smudge. It's too human. I'm for
mechanical art. (9)

I think an artist is anybody who does something well. (3)

———

I made comic strips before I made the silk screen things. (38)

———

Mass art is high art. (15)

———

I don't believe in painting because I hate objects. (38)

———

I'm still a commercial artist. I was always a commercial artist. (3)

———

What's a commercial artist?
I don't know—someone who sells art. (30)

———

When I came to New York, I went directly into commercial art. ... I guess if I had thought art was that simple, I probably would have gone into gallery art rather than commercial, but I like commercial. Commercial art at that time was so hard because photography had really taken over, and all of the illustrators were going out of business really fast. (23)

———

Pop art has more fathers than Shirley Temple had in her movies. I don't want to know who the father of this movement is. (9)

———

Everybody was finding a different thing. I had done the comic strips, and then I saw Roy Lichtenstein's little dots, and they were so perfect. So I thought I could not do the comic strips, because he did them so well. (23)

———

How many painters are there? Millions of painters, and they're all pretty good. (5)

———

How can you say that an abstract expressionist is better than a pop artist? (5)

———

I think every painting, every image should be clear and simple and the same as the first one, but I haven't been able to do that. (5)

I think it would be so great if more people would take up silk screens so that, in turn, no one would know whether my picture was mine or whether it was somebody else. (5)

It's too hard to be creative. (5)

In grade school, they make you copy pictures from books. I think the first one was Robert Louis Stevenson. (1)

An artist is somebody who produces things that people don't need to have but that he, for some reason, thinks it would be a good idea to give them. (7)

My assistant Gerry Malanga … did a lot of my paintings … I just selected the subjects, things that I didn't have to change much. (2)

———

I just happen to like ordinary things. When I paint them, I don't try to make them extraordinary. I just try to paint them ordinary-ordinary. (9)

———

I like all paintings. (23)

———

Everybody is creative. (35)

———

When I took up silk screening, it was to more fully exploit the preconceived image through the commercial techniques of multiple reproduction. (9)

———

We don't have any feeling about [paintings] at all, even when we are doing them. (2)

———

So many people seem to prefer my silver-screenings of movie stars to the rest of my work. It must be the subject matter that attracts them, because my death and violence paintings are just as good. (9)

———

Too many people who say my work is vacuous are judging it either from a reduced illustration or even as an abstract idea. ... I think someone should see my paintings in person before he says they're vacuous. (9)

———

Nobody really looks at anything; it's too hard. (9)

———

"Zennish." That's a good word. That's a good title for ... my new book. (3)

———

I don't believe in painting because I hate
objects and I hate to go to museums and see
pictures on the wall because they look
so important and they don't really
mean anything. (14)

———

I got tired of just setting the camera up
because it just means repeating the same idea
over again so I'm changing, I'm trying to see
what else the camera can do. (14)

———

I guess I paint best. I've done it longer than
the other things, like making movies. (22)

———

Being a wall painter or a housepainter is better [than being an artist]. You make more money as a housepainter. (1)

———

I'll bet there are a lot of artists that nobody hears about who just make more money than anybody. The people that do all the sculptures and paintings for big building construction. We never hear about them, but they make more money than anybody. (1)

———

I get so tired of painting. … It's so boring painting the same picture over and over. (1)

———

I do mostly portraits. So it's just people's faces, not really any ideas. (1)

———

I started [using photo silk screens] when I was printing money. I had to draw it, and it came out looking too much like a drawing, so I thought, *Wouldn't it be a great idea to have it printed?* Somebody said you could just put it on silk screens. So when I went down to the silk screener, I just found out that you could reproduce photographs. (1)

———

I'd rather do new stuff. The old stuff is better to talk about than to see. It always sounds better than it really is. (1)

———

Women are the world's major artists. (32)

———

I always thought that most artists were women—you know, the ones that did the Navajo Indian rugs, American quilts, all that great hand-painting on '40s clothes. (1)

———

I really would rather do just a silk screen of the face without all the rest, but people expect just a little bit more. That's why I put in all the drawing. (25)

———

I like every art in New York. It's so terrific and there's so much of it. (25)

———

There are so many artists that are so good now that it's very hard to pick out one or two. (25)

―――――

It's hard for me to go to galleries because the kids stop me all the time. (25)

―――――

I don't see why one Jasper Johns sells for three million and one sells for four hundred thousand. They were both good paintings. (3)

People think that my art is so expensive, and they're amazed when they find out that they can just walk in and buy one. (25)

———

If only I had stayed with doing the Campbell's Soup well, because everybody only does one painting anyway. (23)

———

There are so many galleries. Every day a new one opens up, so there is room for everybody. (23)

———

I really think you could have a machine that paints all day long for you and do it really well, and you could do something else instead, and you could turn out really wonderful canvases. But ... [then] this morning I went to the handbag district, and there were people that spend all day just putting in rhinestones with their hands, which is just amazing, that they do everything by hand. It would be different if some machine did it. (23)

———

The Canadian Government spokesman said that your art could not be described as original sculpture. Would you agree with that? Yes.

Why do you agree?
Well, because it's not original.

You have just then copied a common item?
Yes.

Why have you bothered to do that? Why not create something new?
Because it's easier to do.

Well, isn't this sort of a joke then that you're playing on the public?
No. It gives me something to do. (29)

———

It's just like a person who spends more time on one picture. I just spend more time doing more than one picture. (30)

———

I like doing the same thing over again. (30)

———

I really believe in empty spaces, although, as an artist, I make a lot of junk. (7)

———

I'm working on a sculpture since I didn't want to paint anymore. I thought that I could give that up and do the movies, but then I thought there must be a way that I have to finish [painting] off. And I thought the only way is to make a painting that floats. I asked Billy Klüver to help me make a painting that floats, and he thought about it and he came up with the silver [balloons] ... I'm working on now. (38)

——————

People thought we were so silly, and we weren't. Now maybe we'll have to fake a little and be serious. But then, that would be faking seriousness, which is sort of faking. But we were serious before, so now we might have to fake a little just to make ourselves look serious. (31)

———

Why should I be original? Why can't I be non-original? (9)

———

Rothko's paintings are full of movement ... all that shimmering and hovering. How can they be monumental? I've always thought they were big empty spaces. (9)

———

It seems like every year there's one artist for that year. The people from twenty years ago are still around. I don't know why. The kids nowadays—there's just one a year. (30)

———

I've become a commercial artist again, so I just have to do portraits and stuff like that. You know, you start a new business, and to keep the business going, you have to keep getting involved. (23)

———

Would you call your art anti-art?
No, it's any art. (6)

———

Empty space is never-wasted space. Wasted space is any space that has art in it. (7)

———

I like everybody's art. (6)

————

Do you think that computers will play a larger and larger role in art? I think that after graffiti art. ... When the machine comes out fast enough. It will probably take over from the graffiti kids. (15)

————

Would you like to see your pictures on as many walls as possible? No, I like them in closets. (30)

————

If you can paint walls you can paint canvases. It's real easy. (6)

————

Film and Technology

In my early films, I wanted to *paint* in a new medium. (19)

———

The kids at college don't have to read anymore. They can look at movies, or make them. (17)

———

Hollywood films are just planned out commercials. (19)

———

[My films] are better talked about than seen. (3)

———

A picture just means I know where I was every minute. That's why I take pictures. It's a visual diary. (27)

———

I've always *believed* in television. (19)

———

I just [take pictures] because the camera is something to carry around in my pocket. (27)

———

I shoot at least two rolls a day. (27)

———

I think the first photograph I did was a ballplayer. It was a way of showing action. (1)

———

When I started out, art was going down the
drain. The people who used to [do the]
magazine illustrations and the covers were
being replaced by photographers. (3)

———

If you're going to make movies,
you've got to have sound. (13)

———

[It took] a few hours [to become proficient
with a videotape recorder]. All you really have
to master is the picture rectifier which
compensates for the light in the room.
Once you know that, it's just a matter
of keeping your hands clean. (13)

———

We like to take advantage of static. We
sometimes stop the tape to get a second image
coming through. As you turn off the tape
it runs for several seconds and you get this
static image. It's weird. So fascinating. (13)

———

When I first started out in New York, art was
out and photography was in, so I got a
camera and set up a darkroom. (27)

———

I'm trying to see what else the camera can do.
(38)

———

I use a Chinon [camera]. It has automatic
focus. (27)

———

The better the lens, the more potential you have for good picture making. (13)

———

Synchronized sound is one of the most exciting things about home videotapes. (13)

———

We have to make our movies look the way they do because if you can make them look better bad, at least they have a *look* to them. But as soon as you try to make a better movie look good without money, you just can't do it. (17)

———

You get used to cutting off things. It makes
the movie more mysterious and glamorous.
(17)

———

All my painting money goes into
[making movies]. (13)

———

I think movies are becoming novels and it's
terrific that people like Norman Mailer and
Susan Sontag are doing movies now. That's the
new novel. Nobody's going to read anymore.
It's easier to make movies. (17)

———

I like all the Hollywood people, the kind of
movies I can't really make. (18)

———

In the late '50s I started an affair with my television which has continued until the present, when I play around in my bedroom with as many as four at a time. But I didn't get married until 1964 when I got my first tape recorder. My wife. My tape recorder and I have been married for ten years now. When I say "we" I mean my tape recorder and me. A lot of people don't understand that. (7)

———

A television day is like a twenty-four-hour movie. The commercials don't really break up the continuity. The programs change yet somehow remain the same. (19)

———

I used to collect photos from the drugstore that people forgot to pick up. I have boxes of those. (27)

———

Scripts bore me. It's so much more exciting not to know what's going to happen. (19)

———

We never edited our films before because we wanted to keep the same look and the same mood. You lose this when you try to re-create a scene days later after you've gotten back the processed film. Therefore, we just accepted whatever we got. Now with videotape, we can do instant retakes and maintain our spontaneity and mood. It's terrific. It has been a great help. (13)

———

I don't think plot is important. If you see a
movie, say, of two people talking, you can
watch it over and over again without being
bored. You get involved—you miss things—
you come back to it—you see new things.
But you can't see the same movie over again
if it has a plot because you already
know the ending. (19)

———

I really do think movies should arouse you.
(19)

———

[My mother] doesn't even know I make
movies. (21)

———

The tape machine is so easy to use. Anyone can do it. (13)

———

Anyone can take a good picture. Anyone can take a picture. (27)

———

Sixties actors were all peculiar-looking people and now the new stars are really good looking, like Christopher Reeve. (25)

———

Lester [Persky] had a good eye. He was doing the eight-hour commercial. I guess that's where I got the idea for doing things long. (1)

———

Nobody is interested in color pictures, so we do black-and-white … color makes it more like a photograph. You have to think of it as a photograph. But in black-and-white it's just a picture. (27)

———

I only talk to the people [that I photograph] when I have to. The other people in my pictures are miles away. These are just snapshots. (27)

———

People get too excited and try to take all their pictures at the beginning of an event. They just stand around at the end when, I think you can get the best pictures ... I should [wait around], but I always take my pictures at the beginning. The good pictures are at 4 in the morning, and I go to bed at 11:30. (27)

I like comedies. I like to see kids' movies. (6)

Spielberg ... said that he saw my movie *Sleep* when he was about twelve and that inspired him to make a movie called *Snore*. (4)

Cabbed to see *Blade Runner*. The movie was dark.
I don't know if it's really abstract or
really simple. (4)

———

All photography is pop, and all
photographers are crazy. (27)

———

Anybody can make a good movie, but if you
consciously try to do a bad movie, that's
like making a *good* bad movie. (19)

———

What is your favorite movie?
Just the last one I've seen. (6)

———

Every bad picture is a good picture. (27)

———

People and Places

I always get my ideas from people. (20)

————

I should trade screens with Bob Rauschenberg.
Oh, wouldn't that be fantastic! (5)

————

I think people are getting to a point where
they don't want to think. (11)

————

I always think that everybody is my friend. (21)

————

I'm really excited about all the kids coming
up, like Keith Haring and Jean-Michel
[Basquiat] and Kenny Scharf. (23)

————

I've never met a person I couldn't call a beauty.

(7)

[New York] is actually a country in itself. It's different from any other place in the world.

(24)

Everybody should be a machine. (5)

My first big break was when John Giorno pushed me down the stairs. No, actually my first big break was meeting Emile de Antonio, who now lives across the street. He laughed a lot and that encouraged me. (1)

I didn't do anything for fun [when I was a teenager]. I think maybe once I went down to see a Frank Sinatra personal appearance with Tommy Dorsey. (1)

The lady from *Glamour*, Tina Fredericks, said that when I got out of school she'd give me a job. So I got out and came back. That was my first job. She gave me a shoe to do. (1)

[I] ran into Bill Cunningham on his bike, I just wish I could do what he does, just go everywhere and take pictures all day. (33)

I like … Rauschenberg and Twombly and Paul Klee. … And I like American primitive painters. I just like everyone, every group. Grant Wood, Ray Johnson. (1)

———

I always liked Ellsworth [Kelly]'s work, and that's why I always painted a blank canvas. I loved that blank canvas thing and I wish that I had stuck with the idea of just painting the same painting, like the soup can, and never painting another painting. (25)

———

I used to love [Grant Wood]'s work. But my favorite artist is now Paul Cadmus. I also like George Tooker. (25)

———

There was a show at the Whitney of young
artists that I liked—Lynda Benglis and
the young guy who does the chairs
[Scott Burton]. (25)

————

[Dalí]'s certainly been around a long time.
But it's hard to understand what he is saying
most of the time. (2)

————

[Salvador] Dalí was really sweet, he'd brought
a plastic bag full of his used-up palettes as
a present to me. (4)

I want [Henry Geldzahler] to care. Whatever
anyone else says has no value to me
concerning my work. I don't need approval.
(2)

I think Chris Burden is terrific. I really do. (1)

I read Cecil Beaton's books on going back to
Paris after the war. They were fascinating. (35)

I love [Marc Chagall]'s work very much.
I never had any thought of copying his art,
but I did feel that I could express my
ideas as he has. (2)

You know who I think is so interesting ... you know well, John Cage and Merce Cunningham. (5)

———

[Jean-Michel Basquiat] was just one of those kids who drove me crazy. (4)

———

I want everybody to think alike. ... I want everybody to be the same. (5)

———

I guess I've been influenced by everybody. But that's good. That's pop. (9)

———

People do the same thing every day and that's what life is. Whatever you do is just the same thing. (11)

———

Carroll Baker ... has too much acting ability for me. ... I want real people. (13)

———

Sean [Penn]'s going to be the new Dustin Hoffman. He'll be around a long time. (4)

———

When I was little, I always thought [Jack Smith] was my best director ... the only person I would ever try to copy ... and now since I'm grown up, I just think that he makes the best movies. (13)

———

I think people should do what they want
to do. (16)

———

All my Swiss friends bring me chocolate. (35)

———

Girls are prettier. (16)

———

Now, in New York I just notice how beautiful
all the people are. Since there's no war that
everybody's going to, they have the pick of
the best athletes, models, and actors. (25)

———

My kind of beauty might be different from
your kind of beauty. (16)

———

I believe in low lights and trick mirrors.
I believe in plastic surgery. (7)

———

The men are more attractive there. ... They
just stand around flexing muscles. (35)

———

Meeting people in Aspen made me aware
of the land. (27)

———

I sleep with my clothes on in hotel rooms. ...
It's horrible. But not under the covers, if
you're tucked in with your shoes on and
everything. It's only if you fall asleep over
the covers that it's uncomfortable. (36)

———

People are only glamorous if you don't see
them. ... [W]hen you see them in person,
they are so different and the whole
illusion is gone. (21)

———

In some circles where very heavy people think
they have very heavy brains, words like
"charming" and "clever" and "pretty" are
all put-downs; all the lighter things in life,
which are the most important things,
are put down. (7)

———

Sometimes you fantasize that people who are really up-there and rich and living it up have something you don't have, that their things must be better than your things because they have more money than you. But they drink the same Cokes and eat the same hot dogs and wear the same ILGWU clothes and see the same TV shows and the same movies. (7)

———

I wanted to buy a house on Long Island, but they didn't want me in the neighborhood. They returned the deposit I made. (21)

———

We looked in the phone book and there were forty Warhols. (35)

———

Tina Turner was great. I thought she was copying Mick Jagger then somebody told me she taught him how to dance. (4)

It is always nice to come back to dirty New York. (21)

We got to Studio 54 for Liz Taylor's party. Liz looked like a—belly button. (4)

Even beauties can be unattractive. If you catch a beauty in the wrong light at the right time, forget it. (7)

I like clean-shaven. (36)

———

Madonna was just a waitress at the Lucky
Strike a year ago. (4)

———

It would be very glamorous to be
reincarnated as a big ring on Pauline
de Rothschild's finger. (7)

———

Who is your favorite comedian?
Whoopi Goldberg. (6)

———

What do you think New York needs the most? A woman mayor. Bella Abzug. She'd be great. (24)

————

[Prostitutes] should be hired by the city. It's part of the city and they should be paid by the city instead of going to jail. (25)

————

I think Detroit is one of the most exciting places I've ever been to. Everybody is so big and beautiful there. (6)

————

When I did my self-portrait, I left all the
pimples out because you always should.
Pimples are a temporary condition and they
don't have anything to do with what you
really look like. Always omit the blemishes—
they're not part of the good picture
you want. (7)

———

I'll paint anybody. Anybody that asks me. (30)

———

I just like to see things used and reused. It
appeals to my American sense of thrift. (9)

———

Church is a fun place to go. (3)

———

I like church. It's empty when I go. I walk around. There are so many beautiful Catholic churches in New York. (1)

———

I just can't wait to get back to New York. I think it's the best place in the world. (24)

———

Did you hear those people that just walked by? They said "Oh, there's Andy Warhol—oh, we don't care." That's why I go shopping here. (26)

———

I think girls and boys in leather are gorgeous. (16)

———

I don't really believe in clothes. I really feel
the body is so beautiful. (16)

———

I think everybody should like everybody. (5)

———

There's not really very much to say about me.
(38)

———

SOURCES

1. O'Brien, Glenn. "Andy Warhol on Junk Food, Coca-Cola, Drugs, Painting, God and His Morning Routine," June 1977. Published in *Interview*, February 4, 2019. https://www.interviewmagazine.com/art/andy-warhol-glenn-obrien-1977-interview.

2. McIlhenny, Sterling, and Peter Ray. "Inside Andy Warhol." *Cavalier*, September 1966. https://americansuburbx.com/2014/09/interview-inside-andy-warhol-1966.html.

3. Taylor, Paul. "The Final Interview." *Flash Art*, April 1987. https://andy.persona.co/Interview-Part-1.

4. Warhol, Andy. *The Andy Warhol Diaries*. New York: Grand Central Publishing, 1989.

5. "'What is Pop Art?' A Revised Transcript of Gene Swenson's 1963 Interview with Andy Warhol." Transcribed and edited by Jennifer Sichel. *Oxford Art Journal*, 2018, 1–25. https://repository.si.edu/bitstream/handle/10088/35252/Sichelkcy001.pdf?sequence=1&isAllowed=y.

6. Crandall, Jordon. "Andy Warhol," 1986. Reprinted in *I'll Be Your Mirror: The Selected Andy Warhol Interviews*, edited by Kenneth Goldsmith. New York: Carroll & Graf, 2004, 348–81.

7. Warhol, Andy. *The Philosophy of Andy Warhol*. New York: Harcourt Brace Jovanovich, 1975.

8. "Inside the Factory: An Interview with Andy Warhol." *CBC Archives*. https://www.cbc.ca/archives/inside-the -factory-an-interview-with-andy-warhol-1.4769842.

9. Bourdon, David. "Warhol Interviews Bourdon," 1962–63. Reprinted in *I'll Be Your Mirror: The Selected Andy Warhol Interviews*, edited by Kenneth Goldsmith. New York: Carroll & Graf, 2004, 6–14.

10. Smith, Edward Lucie. "Andy Warhol." *BBC Radio 4*. March 17, 1981. https://www.youtube.com/watch?v= _wKh2ZdeZjk.

11. Hirschman, Ruth. "Pop Goes the Artist," 1963. Reprinted in *I'll Be Your Mirror: The Selected Andy Warhol Interviews*, edited by Kenneth Goldsmith. New York: Carroll & Graf, 2004, 27–46.

12. Malanga, Gerard. "Andy Warhol: Interviewed by Gerard Malanga," 1963. Reprinted in *I'll Be Your Mirror: The Selected Andy Warhol Interviews*, edited by Kenneth Goldsmith. New York: Carroll & Graf, 2004, 47–52.

13. Ehrenstein, David. "An Interview with Andy Warhol," 1965. Reprinted in *I'll Be Your Mirror: The Selected Andy Warhol Interviews*, edited by Kenneth Goldsmith. New York: Carroll & Graf, 2004, 63–70.

14. Slate, Lane. "USA Artists: Andy Warhol and Roy Lichten-
 stein," 1966. Reprinted in *I'll Be Your Mirror: The Selected
 Andy Warhol Interviews*, edited by Kenneth Goldsmith.
 New York: Carroll & Graf, 2004, 79–84.

15. Wright, Guy, and Glenn Suokko. "Andy Warhol: An Artist
 and His Amiga," 1985. Reprinted in *I'll Be Your Mirror: The
 Selected Andy Warhol Interviews*, edited by Kenneth Goldsmith.
 New York: Carroll & Graf, 2004, 333–47.

16. Reilly, Robert. "Untitled Interview," 1966. Reprinted in *I'll
 Be Your Mirror: The Selected Andy Warhol Interviews*, edited by
 Kenneth Goldsmith. New York: Carroll & Graf, 2004,
 110–17.

17. Gelmis, Joseph. "Andy Warhol," 1969. Reprinted in *I'll Be
 Your Mirror: The Selected Andy Warhol Interviews*, edited by
 Kenneth Goldsmith. New York: Carroll & Graf, 2004,
 160–69.

18. Netzer, Robert, and Curtis Roberts. "We're Still All Just
 Experimenting," 1969. Reprinted in *I'll Be Your Mirror: The
 Selected Andy Warhol Interviews*, edited by Kenneth Goldsmith.
 New York: Carroll & Graf, 2004, 170–83.

19. Kent, Letitia. "Andy Warhol, Movieman: 'It's Hard to Be
 Your Own Script,' " 1970. Reprinted in *I'll Be Your Mirror:
 The Selected Andy Warhol Interviews*, edited by Kenneth
 Goldsmith. New York: Carroll & Graf, 2004, 185–90.

20. Malanga, Gerard. "A Conversation with Andy Warhol," 1971. Reprinted in *I'll Be Your Mirror: The Selected Andy Warhol Interviews*, edited by Kenneth Goldsmith. New York: Carroll & Graf, 2004, 191–96.

21. Gruskin, George. "Who Is This Man Andy Warhol?," 1973. Reprinted in *I'll Be Your Mirror: The Selected Andy Warhol Interviews*, edited by Kenneth Goldsmith. New York: Carroll & Graf, 2004, 200–220.

22. Winakor, Bess. "Andy Warhol's Life, Loves, Art, and Wavemaking," 1975. Reprinted in *I'll Be Your Mirror: The Selected Andy Warhol Interviews*, edited by Kenneth Goldsmith. New York: Carroll & Graf, 2004, 221–28.

23. Buchloh, Benjamin. "An Interview with Andy Warhol." http://thecomposingrooms.com/research/reading/2015/andy-warhol-october-files_interview.pdf.

24. Demers, Claire. "An Interview with Andy Warhol: Some Say He's the Real Mayor of New York," 1977. Reprinted in *I'll Be Your Mirror: The Selected Andy Warhol Interviews*, edited by Kenneth Goldsmith. New York: Carroll & Graf, 2004, 265–76.

25. Bockris, Victor. "Dinner with Andy and Bill, February 1980," 1980. Reprinted in *I'll Be Your Mirror: The Selected Andy Warhol Interviews*, edited by Kenneth Goldsmith. New York: Carroll & Graf, 2004, 277–91.

26. Brobston, Tracy. "A Shopping Spree in Bloomingdale's with Andy Warhol," 1981. Reprinted in *I'll Be Your Mirror: The Selected Andy Warhol Interviews*, edited by Kenneth Goldsmith. New York: Carroll & Graf, 2004, 301–11.

27. Bogre, Michelle. "Q&A: Andy Warhol," 1985. Reprinted in *I'll Be Your Mirror: The Selected Andy Warhol Interviews*, edited by Kenneth Goldsmith. New York: Carroll & Graf, 2004, 312–20.

28. Thames Television, 1976. "Pets." YouTube video, https://www.youtube.com/watch?v=NZkjWW-mENk.

29. "Andy Warhol: A Documentary Film," Steeplechase Films, Daniel Wolf, High Line Productions, and Thirteen/WNET New York, 2006. Directed by Ric Burns. YouTube video, https://www.youtube.com/watch?v=nGGk7x6PK0Y.

30. "Andy Warhol Interview." Tomorrowpictures.TV, June 2, 2015. YouTube video, 1:00:05. https://www.youtube.com/watch?v=-SRuO4ch344&ab_channel=Tomorrowpictures.TV.

31. Leonard, John. "The Return of Andy Warhol." *New York Times Magazine*, November 10, 1968.

32. Gopnik, Blake. "Think You Know Andy Warhol? Here Are Five Truths that May Surprise." *New York Times*, November 1, 2018. https://www.nytimes.com/2018/11/01/arts/think-you-know-andy-warhol-here-are-five-truths-that-may-surprise.html?smid=url-share.

33. "The Lives They Lived—Bill Cunningham." *New York Times Magazine*, December 21, 2016.

34. Lingeman, Richard R. "Publishing: Warhol Productions." *New York Times*, August 6, 1976, https://www.nytimes.com/1976/08/06/archives/publishing-warhol-productions.html.

35. Colacello, Bob, and Andy Warhol. "New Again: Truman Capote." *Interview*, September 15, 2016. https://www.interviewmagazine.com/culture/new-again-truman-capote-1#_.

36. Warhol, Andy. "Dustin Hoffman Has the Best Day of His Life with Andy Warhol." *Interview*, April 12, 2016. https://www.interviewmagazine.com/film/dustin-hoffman-has-the-best-day-of-his-life-with-andy-warhol.

37. Warhol, Andy. "Q & Andy: Kathy Bates." *Interview*, August 2, 2017. https://www.interviewmagazine.com/culture/andy-warhols-interview-interview-interview-kathy-bates.

38. "Andy Warhol Interview 1966." YouTube video, 00:14:10. Posted by vabethany, February 13, 2013. https://www.youtube.com/watch?v=p7nw9Up54pg.

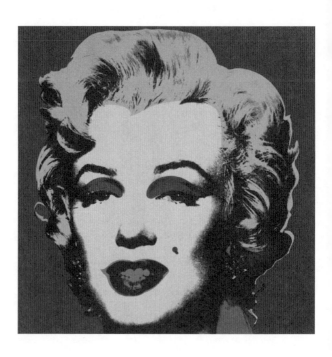

CHRONOLOGY

1920s

1928
Andrew Warhola[1] is born in Pittsburgh on August 6
 to Julia and Andrej Warhola, Carpatho-Rusyn immi-
 grants from the village of Mikova in present-day
 Eastern Slovakia. He has two older brothers, Paul
 and John.
The family regularly attends St. John Chrysostom
 Byzantine Catholic Church.

Matt Wrbican, Archivist, The Andy Warhol Museum.
Copyright 2006 The Andy Warhol Museum

1 While "Warhola" was Andy's last name, at some point in
 the late 1940s, he dropped the "a." For simplicity's sake
 and for the purposes of this chronology, we have used
 "Warhol" throughout.

1930s

1934
After renting a succession of small apartments, the
Warholas purchase a home at 3252 Dawson Street.
Warhol lives there until he moves to New York in
1949.

1936
Warhol projects cartoon images on the walls of his home.

1937
Warhol becomes interested in photography and takes
pictures with the family's Kodak Brownie camera.
An area of the Warholas' basement is cleared for use
as a darkroom.
From about 1937 to 1941, he attends free Saturday art
classes at the Carnegie Institute.
After contracting rheumatic fever, Warhol is stricken
with Saint Vitus's dance (Sydenham's chorea) and
confined to home for more than two months,

during which his mother encourages his interest in art, comics, and movies.

1939
Warhol begins collecting photographs of movie stars.

1940s

1942
Warhol signs a portrait he painted of his friend Nick Kish with the name "A. Warhol."

Warhol graduates from Holmes Elementary School and enters Schenley High School, where he receives the highest marks in his art classes.

Andrej Warhola dies after a lengthy illness. He had saved several thousand dollars to be used for Warhol's education.

1945
Warhol is admitted to the Carnegie Institute of Technology (now Carnegie Mellon University) and enrolled in the Department of Painting and Design.

1947–48

Throughout this time, Warhol experiments with his "blotted line technique," which becomes a mainstay of his 1950s commercial work.

Warhol works at a summer job in the display department at the Joseph Horne department store in downtown Pittsburgh.

1948

Warhol's painting *I Like Dance* and his print *Dance in Black and White* are included in the annual exhibition of the Associated Artists of Pittsburgh.

Warhol serves as art editor for the student magazine *Cano*.

1949

Warhol's painting *The Broad Gave Me My Face, But I Can Pick My Own Nose* is rejected for the annual exhibition of the Associated Artists of Pittsburgh. Juror George Grosz, the German artist, is said to have praised the work. It is later included in a student exhibition at Pittsburgh's Arts and Crafts Center.

Warhol graduates from Carnegie Tech with a bachelor
 of fine arts degree in pictorial design. His professors
 include Samuel Rosenberg and Robert Lepper.
Shortly after graduating, Warhol moves to New York City.
Warhol begins to work as a commercial artist, usu-
 ally under the name Andy Warhol. Throughout the
 1950s and early 1960s, he illustrates a great variety
 of published projects and designs department store
 windows.

1950s

1951

Warhol receives an Art Directors Club Medal for his
 newspaper illustrations that advertised the CBS Radio
 feature *The Nation's Nightmare*. He receives numerous
 graphic arts awards throughout the 1950s.

1952

Warhol's first solo exhibition, *Fifteen Drawings Based on the
 Writings of Truman Capote*, is held at the Hugo Gallery,
 New York.

Julia Warhola moves to New York, where she lives with
her son until 1971.

1953

Warhol produces the illustrated books *A Is an Alphabet*
and *Love Is a Pink Cake*, "by Corkie and Andy," with his
friend Ralph T. Ward. He gives these and other books
to clients and associates, and also sells them through
shops.

1954

Warhol exhibits in both group and solo shows at the
Loft Gallery, New York. Among his works are marble-
ized and folded or crumpled paper works displayed
on the walls, floors, and ceiling.

Warhol self-publishes the illustrated book *25 Cats Name
Sam and One Blue Pussy*, with text by Charles Lisanby.
These and Warhol's other books were hand-colored
at "coloring parties" with friends and associates.

Warhol begins frequenting the café Serendipity 3 on East
Fifty-Eighth Street, which is known for its desserts.

1955

Warhol uses hand-carved rubber stamps to create
repeated images that are often hand-colored. He
employs this technique throughout the early 1960s.

The shoe company I. Miller selects Warhol to illustrate its
weekly newspaper advertisements, which become a
great success and run for about three years.

Nathan Gluck is hired as a studio assistant.

1956

Warhol's *Studies for a Boy Book* is exhibited at the Bodley Gal-
lery, New York. During the 1950s, Warhol fills numer-
ous sketchbooks with his drawings of young men.

Warhol exhibits his gold leaf–collaged shoe drawings,
The Golden Slipper Show or Shoes Shoe in America, at the
Bodley Gallery. His gold shoes are published in the
January 21, 1957, issue of *Life* magazine.

A Warhol drawing of a shoe is included in the exhibition
Recent Drawings U.S.A. at the Museum of Modern Art.

Warhol becomes acquainted with the photographer
Edward Wallowitch. He uses images from

Wallowitch's photographs, as well as other photographs and images, in his own works.

Warhol takes a two-month world tour focusing on Asia and Europe with his friend Charles Lisanby.

1957

Warhol self-publishes *A Gold Book*, with many drawings based on Wallowitch's photos.

Andy Warhol Enterprises is legally incorporated.

Warhol undergoes cosmetic surgery on his nose.

1959

With his friend Suzie Frankfurt, Warhol self-publishes *Wild Raspberries*, a cookbook of absurd recipes; the title is a joke referencing Ingmar Bergman's film *Wild Strawberries*.

1960s

1960

Warhol acquires a townhouse at 1342 Lexington Avenue

that accommodates his growing collections of art, furniture, and objects. It also gives him the space to create larger artworks.

Warhol's stage designs appear in performances of the Lukas Foss/Gian Carlo Menotti operetta *Introductions and Good-Byes* at the Festival of Two Worlds in Spoleto, Italy.

1961

Warhol paints his first works based on comics and advertisements by using an opaque projector to enlarge the original image onto a canvas, which he then traces and paints.

Warhol's paintings *Advertisement, Little King, Superman, Before and After,* and *Saturday's Popeye* are shown with a display of dresses in a window at New York's Bonwit Teller department store.

1962

Warhol publishes his first editioned print, *Cooking Pot,* a photoengraving of a detail from a newspaper advertisement.

Warhol uses rubber stamps to create *S & H Green Stamps* and other works, including portrait illustrations for *Harper's Bazaar*.

Warhol bases his *Do It Yourself* paintings on common paint-by-number images.

Warhol makes paintings of entire newspaper front pages.

After creating a few series of works using hand-drawn silk screens, he begins to use the photographic silk-screen technique.

Warhol experiments with instant photography, which becomes essential to his portrait process in the early 1970s.

After silk-screening portraits of the teen idols Natalie Wood, Troy Donahue, and Warren Beatty, Warhol begins his photographic silk-screened *Marilyn* paintings after her death.

Warhol starts a series of paintings of suicides and car crashes.

Warhol's hand-painted *Campbell's Soup Can* paintings are shown at the Ferus Gallery, Los Angeles.

Warhol's recent paintings are shown at the Stable Gallery, New York.

Warhol is included in the exhibition *New Painting of Common Objects* at the Pasadena Art Museum.

Warhol is featured in a *Time* magazine article on pop artists.

1963

Warhol hires Gerard Malanga as his studio assistant.

Warhol makes multiple-image silk-screened portraits of the collector Ethel Scull and others based on photographs of his subjects taken in common photo booths.

Using publicity photographs as sources, Warhol begins paintings of Elvis Presley and Elizabeth Taylor.

Warhol buys a 16 mm movie camera and makes the films *Sleep, Kiss, Haircut, Tarzan and Jane Regained ... Sort Of*, and the first of more than five hundred screen tests.

While in Los Angeles for the exhibition of his *Elvis* and *Liz* paintings, Warhol meets Marcel Duchamp at his exhibition in Pasadena and attends a "Movie Star Party" arranged in his honor by Dennis Hopper.

Warhol is included in the exhibition *Six Painters and the Object* at the Solomon R. Guggenheim Museum, New York.

Warhol is included in the exhibition *The Popular Image* at the Washington Gallery of Modern Art, Washington, DC. The exhibition later travels to London.

Baby Jane Holzer, Taylor Mead, and Ondine (Bob Olivo) become Warhol's associates at about this time and act in his films. Warhol's first superstars, they are synonymous with his work.

Warhol rents an abandoned firehouse near his home for use as a painting studio.

Warhol designs costumes for a Broadway production of *The Beast in Me*, by James Thurber. His work isn't credited because he is not a union member.

1964

Warhol establishes his studio at 231 East Forty-Seventh Street, soon to be known as "the Factory." It is painted silver and covered with aluminum foil by Billy Name (Billy Linich), a theatrical lighting designer whom Warhol had met the year before.

Warhol makes the Thirteen Most Wanted Men mural for the facade of the New York Pavilion at the 1964 New York World's Fair. Officials object to the work, and it is painted over in silver paint.

Brillo Boxes and other box sculptures by Warhol are exhibited at the Stable Gallery, New York.

After President Kennedy's assassination, Warhol begins his series of Jackie paintings.

Warhol begins his Flowers paintings, which are shown at the Castelli Gallery this year and in Paris the next.

Warhol's paintings of car crashes and suicides are shown at Galerie Ileana Sonnabend in Paris and elsewhere in Europe.

Warhol makes the films Blow Job, Eat, Empire, and Harlot (his first with live sound). His film Andy Warhol Films Jack Smith Filming "Normal Love" (1963) is confiscated in a raid by the New York City Police Department—and lost.

Warhol acquires his first tape recorder, which later becomes his constant companion.

Warhol's painting Orange Disaster No. 5 is included in the Pittsburgh International (now the Carnegie

International) exhibition at the Carnegie Institute,
Pittsburgh.

A Warhol film installation with a soundtrack by La
Monte Young is exhibited at the New York Film
Festival.

Warhol receives the Independent Film Award from *Film
Culture*, the avant-garde film periodical edited by
Jonas Mekas.

1965

Warhol makes the films *Poor Little Rich Girl*, *Vinyl*, *Kitchen*,
Lupe, *Outer and Inner Space*, *My Hustler*, and others.

Warhol designs the cover for an issue of *Time* magazine.

Warhol exhibits his video art, the first artist to do so.

While in Paris for the opening of his *Flowers* exhibition at
the Galerie Ileana Sonnabend, Warhol describes him-
self as a "retired artist" who plans to devote himself
to film.

The opening night crowd overwhelms the retrospective
of Warhol's work at the Institute of Contemporary
Art, Philadelphia.

Warhol meets Paul Morrissey, one of the most important figures for his work in film.

Edie Sedgwick stars in about ten of Warhol's films.

Superstars Brigid Polk (Brigid Berlin) and Ultra Violet (Isabelle Collin Dufresne) begin to frequent the Factory at about this time.

Film producer Lester Persky hosts "The Fifty Most Beautiful People" party at the Factory. Judy Garland, Rudolf Nureyev, Tennessee Williams, Allen Ginsberg, Montgomery Clift, and others attend.

1966

Warhol produces the Exploding Plastic Inevitable, multimedia shows featuring the Velvet Underground rock and roll band, performance, film, and light shows.

At the Castelli Gallery, Warhol exhibits his *Cow Wallpaper* in one room and fills a second white-walled room with his floating *Silver Clouds*.

Warhol makes the films *The Velvet Underground and Nico* and the *Chelsea Girls*. The *Chelsea Girls* is distributed widely and receives international media attention.

The print editions of *Kiss, Jacqueline Kennedy (I, II, and III), Banana,* and *Self-Portrait* are published. In the following years, Warhol creates more than four hundred print editions.

The first LP album by the Velvet Underground and Nico is produced. The cover, designed by Warhol, shows a banana with vinyl skin that could be peeled off to expose the pink fruit. A larger fine art print is also produced.

The following advertisement appeared in the February 10 issue of the *Village Voice*: "I'll endorse with my name any of the following: clothing AC-DC, cigarettes small, tapes, sound equipment, ROCK N' ROLL RECORDS, anything, film, and film equipment, Food, Helium, Whips, MONEY!! love and kisses ANDY WARHOL, EL 5-9941."

Warhol gives away the bride at the Mod Wedding at the Michigan State Fairgrounds Coliseum in Detroit. The event featured an Exploding Plastic Inevitable performance.

Warhol and his superstars begin to frequent the back

room of the notorious bar-restaurant Max's Kansas City on Union Square.

Warhol is invited to author Truman Capote's "Black and White Dance," referred to as "the party of the decade."

1967

Warhol makes *Self-Portrait* paintings, which are included in the United States Pavilion at Expo '67 in Montreal.

The films *Bike Boy*, *I, a Man*, and *The Nude Restaurant* are made.

Warhol designs the poster for the fifth New York Film Festival.

Two Warhol books are published: *Andy Warhol's Index (Book)* and *Screen Tests/A Diary*, a collaboration between Warhol and Malanga.

The FBI report on Warhol's activities during location shooting in Oracle, Arizona, for his film *Lonesome Cowboys*. On the same trip, location footage is shot in La Jolla, California, for *San Diego Surf*.

Warhol gives a college lecture tour with Allen Midgette impersonating him for several engagements.

Warhol meets Frederick W. Hughes, who becomes a
close associate and Warhol's exclusive agent and
business manager.

Joe Dallesandro, Candy Darling, and Viva become
superstars.

1968

In January, Warhol moves his studio to a white-walled
office space on the sixth floor of Thirty-Three Union
Square West.

In February, Malanga is nearly imprisoned for forging
Warhol paintings in Rome.

On June 3, Valerie Solanas, who appeared in Warhol's
film I, a Man and was the founder and sole member
of S.C.U.M. (Society for Cutting Up Men), shoots
Warhol in his studio.

Warhol produces the film Flesh, directed by Paul
Morrissey, and makes Blue Movie. He begins to take a
less active role in filmmaking.

The Schrafft's restaurant chain hires Warhol to create
a television advertisement for the "Underground
Sundae."

A transcription of Warhol's tape recordings featuring Ondine, entitled *a, A Novel*, is published by Grove Press.

Warhol's *Silver Clouds* are used as the set for Merce Cunningham's dance *RainForest*.

A retrospective of Warhol's work is held at the Moderna Museet, Stockholm, and travels throughout Scandinavia.

Warhol's work is included in the exhibition *Documenta 4* in Kassel, Germany.

Jed Johnson is hired as an assistant. Soon after, he begins living with Warhol and his mother.

1969

Warhol curates *Raid the Icebox I*, a selection from the storage rooms of the Museum of Art at the Rhode Island School of Design.

Warhol produces the film *Trash*, directed by Paul Morrissey.

The first issue of *Interview* magazine is published.

Warhol is included in the Metropolitan Museum of Art's *New York Painting and Sculpture: 1940–1970*.

Vincent Fremont begins to work for Warhol. He becomes a close associate on video and television projects, and eventually becomes his executive manager.

1970s

1970

Warhol's production of commissioned portraits increases in the early 1970s. Most are based on his Polaroid photographs of sitters, including collectors, friends, and celebrities.

Warhol creates the *Rain Machine*, an installation that incorporates a water shower and 3-D lenticular prints of flowers, in connection with the Los Angeles County Museum of Art's Art and Technology Program. The *Rain Machine* is exhibited in the United States Pavilion at Expo '70 in Osaka, Japan.

Warhol acquires a portable video camera and begins to work regularly with video.

A major retrospective of Warhol's work is held at the Pasadena Art Museum. The exhibition later travels to

Chicago, Eindhoven, Paris, London, and New York.

The first monograph on Warhol, written by art historian Rainer Crone, is published.

Bob Colacello begins to work for *Interview*. He eventually becomes the magazine's executive editor.

1971

With Vincent Fremont and Michael Netter, Warhol begins *Factory Diaries*, a series of videotaped recordings of life at the studio.

Warhol designs the album cover of the Rolling Stones' *Sticky Fingers* in collaboration with Craig Braun. The cover, a male torso in jeans with a functioning zipper, is nominated for a Grammy award.

Warhol's play *Pork*, based on his tape recordings, is performed in London and New York.

Warhol and Paul Morrissey acquire a twenty-acre compound in Montauk, Long Island. Lee Radziwill and other friends spend much time there.

Julia Warhola leaves New York and returns to Pittsburgh.

1972

Warhol begins his *Mao* paintings, drawings, and prints.

After publishing his print *Vote McGovern* for a presidential
candidate, the Internal Revenue Service audits
Warhol; he is audited annually until his death.

Warhol produces the films *Women in Revolt!* and *Heat*,
directed by Paul Morrissey.

Warhol removes the films he had directed from
circulation.

Warhol's mother dies in Pittsburgh.

1973

Warhol makes the videos *Vivian's Girls* and *Phoney*,
directed with Vincent Fremont.

Warhol appears in the film *The Driver's Seat* with Elizabeth
Taylor.

Ronnie Cutrone becomes Warhol's studio assistant in
1973 or 1974; he had previously danced with the
Exploding Plastic Inevitable.

1974

Warhol begins assembling *Time Capsules* in standard-sized boxes. This collection of objects and ephemera from his entire life eventually numbers more than six hundred boxes and includes antiques and works of art.

Warhol coproduces the films *Andy Warhol's Dracula* and *Andy Warhol's Frankenstein* (in 3-D), directed by Paul Morrissey.

Mao portraits are exhibited at the Musée Galliera, Paris; they are hung on Warhol's *Mao Wallpaper*.

Warhol moves the studio to 860 Broadway, which becomes known as "the office."

Warhol acquires a townhouse at Fifty-Seven East Sixty-Sixth Street. Jed Johnson decorates the house, which is filled with art and collectibles.

1975

Warhol makes the *Ladies and Gentlemen* paintings, drawings, and prints that depict transvestites.

Warhol makes the video *Fight*, codirected with Vincent Fremont.

The Philosophy of Andy Warhol (From A to B and Back Again) is
 published by Harcourt Brace Jovanovich.
Warhol produces the musical *Man on the Moon*, with book,
 music, and lyrics by John Phillips, directed by Paul
 Morrissey.

1976
Warhol makes *Skull* paintings, drawings, and prints, and
 begins the *Hammer and Sickle* photographs and screen
 prints.
Warhol produces the film *Bad*, directed by Jed Johnson.
Warhol begins dictating his diary to Pat Hackett. It is
 published posthumously and becomes a bestseller.
A retrospective of Warhol's drawings is held at the
 Württembergischer Kunstverein, Stuttgart.

1977
Warhol makes *Torso* paintings and drawings.
Andy Warhol's "Folk and Funk," an exhibition of Warhol's
 folk art collection, is held at the Museum of Ameri-
 can Folk Art, New York.

Warhol begins to frequent the nightclub Studio 54 with
friends Halston, Bianca Jagger, and Liza Minnelli.

1978
Warhol makes *Self-Portraits with Skull* and begins his
Shadows and *Oxidation* paintings.
A retrospective of Warhol's work is held at the
Kunsthaus, Zürich.

1979
Warhol begins to produce the ten-episode video pro-
gram *Fashion*, directed by Don Munroe.
Andy Warhol's Exposures, with photographs by Warhol and
text cowritten with Bob Colacello, is published by
Andy Warhol Books/Grosset and Dunlap.
At the request of BMW, Warhol hand-paints an M1
racing car for the twenty-four-hour Le Mans race.
Warhol's *Shadows* paintings are exhibited at the Heiner
Friedrich Gallery, New York.
Andy Warhol: Portraits of the 70s is presented at the
Whitney Museum of American Art, New York.

1980s

1980

Warhol develops *Andy Warhol's T.V.*, directed by Don
Munroe.

POPism: The Warhol Sixties, by Warhol and Pat Hackett, is
published by Harcourt Brace Jovanovich.

Warhol's photographs are exhibited at the Museum Lud-
wig, Cologne, and the Stedelijk Museum, Amsterdam.

A life mask of Warhol is made for a robot that is
intended for an unrealized theater project, conceived
by Peter Sellars and Lewis Allen.

Jay Shriver becomes Warhol's studio assistant.

In Vatican City, Warhol and Fred Hughes briefly meet
Pope John Paul II.

1981

Warhol makes *Dollar Signs, Knives, Crosses*, and *Guns* works.

Warhol produces and stars in three one-minute episodes
of *Andy Warhol's T.V.*, directed by Don Munroe, for the
television program *Saturday Night Live*.

Warhol begins to be represented by the Zoli modeling
 agency.

1982

The Castelli Gallery exhibits Warhol's *Dollar Sign*
 paintings.
An exhibition of works by Joseph Beuys, Robert
 Rauschenberg, Cy Twombly, and Warhol is shown at
 the Nationalgalerie, Berlin.
Warhol's *Zeitgeist* paintings are shown in the group exhi-
 bition *Zeitgeist* at the Martin-Gropius-Bau, Berlin.
Warhol travels to Hong Kong and Beijing with Fred
 Hughes and photographer Christopher Makos.

1983

Warhol, Jean-Michel Basquiat, and Francesco Clemente
 begin collaborating on paintings. Warhol and Bas-
 quiat become close friends and work together into
 1985.
During this period, Warhol begins a series of works,
 many of them hand-painted, based on advertise-

ments, commercial imagery, and illustrations.

Warhol designs the official poster for the Brooklyn Bridge Centennial.

Warhol appears in a Japanese television commercial for TDK.

1984

The *Paintings for Children* exhibition is held at the Bruno Bischofberger Gallery, Zürich. Small paintings of toys are hung at children's eye level on Warhol's *Fish Wallpaper*.

Warhol makes *Rorschach* paintings.

Warhol makes a music video, *The Cars: Hello Again*, with Don Munroe. The video also features Warhol.

Collaborations: Jean-Michel Basquiat, Francesco Clemente, Andy Warhol is exhibited at the Bruno Bischofberger Gallery, Zürich.

Warhol moves his studio and *Interview* magazine to a former Consolidated Edison building at Twenty-Two East Thirty-Third Street.

1985

Warhol makes *Absolut Vodka* paintings that are used in "Absolut Warhol" advertisements, the first in the series created by artists.

Warhol exhibits his *Invisible Sculpture*, which consists of a pedestal, a wall label, and Warhol himself in a show-case, at the nightclub Area. An earlier version had motion detectors that set off a cacophony of alarms.

Andy Warhol's Fifteen Minutes, directed by Don Munroe, airs on MTV from 1985 to 1987.

America, with photographs and text by Warhol, is published by Harper and Row.

Warhol appears as a guest star in the two hundredth episode of the television program *The Love Boat*, and in a television commercial for Diet Coke.

1986

Warhol makes his *Last Supper* and *Camouflage* paintings.

Warhol's *Self-Portrait* paintings are exhibited at the Anthony d'Offay Gallery, London; his *Oxidation* paintings are shown at Gagosian Gallery, New York.

Warhol options film and television rights to Tama
Janowitz's book *Slaves of New York*.

1987
The collection *Sewn Photographs* is shown at the Robert
Miller Gallery, New York.
Last Supper paintings are exhibited at the Palazzo delle
Stelline, Milan.
After suffering acute pain for several days, Warhol is
admitted to New York Hospital for gall bladder sur-
gery. The operation is successful but complications
during recovery cause his death on February 22. He
is buried near his parents in a suburban Pittsburgh
cemetery.

ACKNOWLEDGMENTS

Although these words belong to Andy Warhol himself, this book is a result of the hard work and dedication of many outstanding individuals.

My sincere thanks to Joel Wachs, Michael Dayton Hermann, and the entire team at the Andy Warhol Foundation. It remains an honor and a privilege to have a part in bringing Andy's words and legacy to the world.

Heartfelt thanks as well to Patrick Moore, Karen Lautenan, José Carlos Diaz, Matthew Newton, and the whole team at the Andy Warhol Museum for their incredible support and encouragement throughout this project.

My sincere appreciation as well to Princeton University Press, especially Michelle Komie, Christie Henry, Terri O'Prey, Cathy Slovensky, Kenneth Guay, Jodi Price, and Kathryn Stevens. We remain extremely grateful to PUP for their continued professionalism, encouragement, and passion for our projects together throughout the years.

Additional thanks go to a celebrated group of friends, colleagues, and supporters of Andy Warhol, including (but not limited to): Hannah Alderfer, Franklin Sirmans, Jeffrey Deitch, AWW, Kenny Scharf, Tony Shafrazi, Phil Tinari, Dieter Buchhart, Gil Vasquez, Julia Gruen, Carlo McCormick, Keith Miller, Hiroko Onoda, Patti Astor, Bill Stelling, Steven Lack, Futura, Daniel Arsham, ASAP Ferg, Sickamore, John Cahill, John Pelosi, Angelo DiStefano, Matt Rich, A$AP Ferg, Sky Gellatly, Andre Rabsen, Carlos "oggizery_los" Desrosiers, Brian Donnelly, Mike Dean, and Louise Donegan.

My thanks as well to Vanessa Lee, Kevin Wong, Keith Estiler, Sarah Sperling, Man Huang, Hassan Ali Khan, Rickey Kim, and Jahan Loh for their global support.

I humbly honor those in memoriam: Kiely Jenkins, Allan Arnold, Bobby Breslau, David Spada, Jean-Michel Basquiat, Keith Haring, Henry Geldzahler, Diego Cortez, Arch Connelly, Michael Stewart, Tseng Kwong Chi, David Wojnarowicz, Adolfo Sanchez, Dan Friedman, Danny Acosta, Richard Marshall, Christine Zounek, and O.W.

Special thanks to Fiona Graham for her invaluable research and organization of this publication. My thanks

as well to Matthew Christensen for his excellent editorial support.

My sincere thanks to Taliesin Thomas for her amazing assistance with many projects and to Steven Rodríguez, Zara Hoffman, and Susan Delson for their continued support.

Finally, I give all my bottomless gratitude to my amazing wife, Abbey, and to my wonderful children, Justin, Ethan, Ellie, and Jonah, for their love and encouragement.

As always, I give endless love and thanks to my mother, Judith.

LARRY WARSH

Andy Warhol (1928–87) was an American artist born into the working-class neighborhood of Oakland in Pittsburgh, Pennsylvania. At an early age, Warhol suffered from Saint Vitus's dance, or Sydenham's chorea, which left a deep impression upon him. During these episodes, Warhol escaped into popular culture, magazines, and comics. In the 1940s, he moved to New York where he studied commercial art. He soon shifted his practice to painting, silk-screen printing, and photography. During the 1960s, Warhol's interest took a strong pivot toward counterculture, sexuality, film, and celebrity. His studio, known as the Factory, established a mode of art making that still exerts influence over contemporary artistic practice and the creation of cultural properties. Early on, Warhol learned the art of fashioning a public persona into a cultural brand. His work was collaborative and studio-based, and without the trappings of intellectualism, preciousness, or conceptualism; in short, he made what he referred to as "commercial art." He was also coy, very funny, and overtly (though performatively) aloof—as evidenced in some of the Warhol-isms collected in this volume. He continues to be celebrated as a groundbreak-

ing artist who moved art and culture in a new direction. Warhol's work is in the permanent collections of many major museums, including the Museum of Modern Art in New York, the Art Institute of Chicago, the Metropolitan Museum of Art, and the Los Angeles County Museum of Art, among others. His work is also exhibited at the Andy Warhol Museum in Pittsburgh, which is the largest North American museum dedicated to a single artist.

Larry Warsh has been active in the art world for more than thirty years as a publisher and artist-collaborator. An early collector of Keith Haring and Jean-Michel Basquiat, Warsh was a lead organizer for the exhibition *Basquiat: The Unknown Notebooks*, which debuted at the Brooklyn Museum, New York, in 2015, and later traveled to several American museums. He has loaned artworks by Haring and Basquiat from his collection to numerous exhibitions worldwide, and he served as a curatorial consultant on *Keith Haring | Jean-Michel Basquiat: Crossing Lines* for the National Gallery of Victoria. The founder of *Museums Magazine*, Warsh has been involved in many publishing projects and is the editor of several other titles published by Princeton University Press, including *Basquiat-isms* (2019), *Haring-isms* (2020), *Futura-isms* (2021), *Abloh-isms* (2021), *Arsham-isms* (2021), *Jean-Michel Basquiat: The Notebooks* (2017), *Keith Haring: 31 Subway Drawings*, and two books by Ai Weiwei, *Humanity* (2018) and *Weiwei-isms* (2012). Warsh has served on the board of the Getty Museum Photographs Council and was a founding member of the Basquiat Authentication Committee until its dissolution in 2012.

ILLUSTRATIONS

ISMs

Larry Warsh, Series Editor

The ISMs series distills the voices of an exciting range of visual artists and designers into captivating, beautifully made books of quotations for a new generation of readers. In turn passionate, inspiring, humorous, witty, and challenging, these collections offer powerful statements on topics ranging from contemporary culture, politics, and race, to creativity, humanity, and the role of art in the world. Books in this series are edited by Larry Warsh and published by Princeton University Press in association with No More Rulers.

Warhol-isms, Andy Warhol
Arsham-isms, Daniel Arsham
Abloh-isms, Virgil Abloh
Futura-isms, Futura
Haring-isms, Keith Haring
Basquiat-isms, Jean-Michel Basquiat
Weiwei-isms, Ai Weiwei